Tangling in the round has always been a favorite pastime of mine. "Round" meaning circular or spherical. Many of my designs curl in on themselves. I especially enjoy working on a circular or oval surface. Round ornaments are my very favorite, but I do enjoy other shapes as well. In this book, we'll explore variations within circles and ovals. Color is used on many of the tangles, while many are in simple black and white.

While these circular shapes and designs aren't mandala's, they are as relaxing and beneficial as if they were. To Zentangle® is to enter a meditative state that allows the tangler to relax, listen better, to increase productivity, focus more, and to look inside themselves to reveal the artist within.

Breathe and try the 5 R's of tangling ~ Relax ~ Reflect ~ Renew ~ Replenish & Reveal
Using the 5 R's can bring you peace and tranquility while you tangle and in your life. Go ahead, you can do it. Follow the steps in this book to become familiar with Zentangle and then tangle your own way to happiness.

Rick Roberts and Maria Thomas invented the art of Zentangle. It is more than just doodling, it is the art of making repetitive marks, allowing your mind and body to relax. Hold the pen in a gentle manner to make marks without pressure. Think of writing on a small egg that you wouldn't want to break helps you achieve this. The ink will easily flow from the pen tip.

Store pens on their side and keep them capped when not in use. This will extend the life of the pens.

Use a pencil to shade with, giving the design a dimensional appearance. Smudge the pencil lines with a blending stump (called a tortillon).

For more info go to:
www.Zentangle.com
www.decorativeartistry.us

Relax your mind & body...

Reflect on your inner self...

Renew your spirit...

Replenish your energy...

Reveal the artist within...

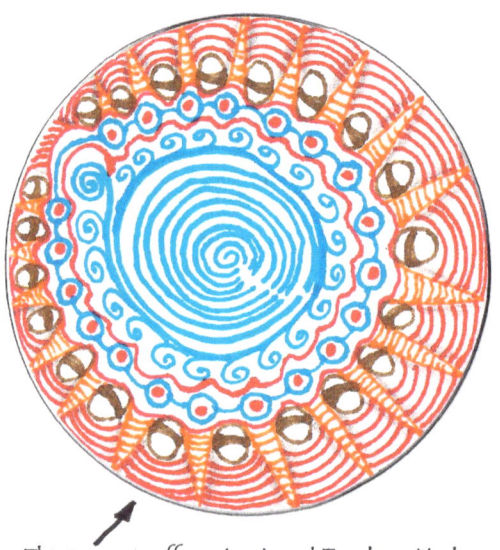

Finding the center of the circle can be done using a ruler. Measure top to bottom and place a mark at the halfway point. Repeat from side to side. This will give you the exact center point.

If you enjoy working without an exact center, then go ahead. It is okay, and there really is no wrong way to tangle, so off-center can be more fun when making your own Zentangle.

On the next page you can try both ways—with a found center point and one without. See where it takes you. There are mistakes ~ only possibilities!

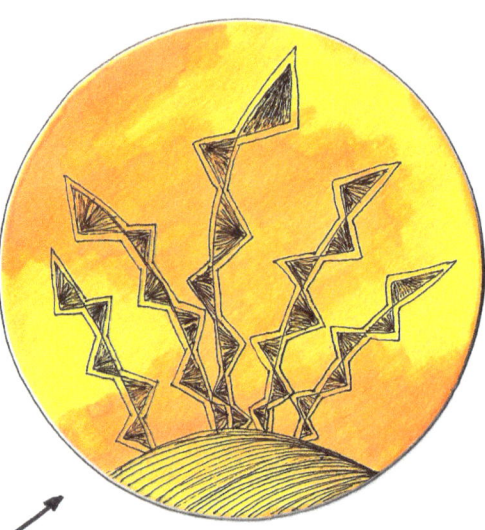

This image is off-center. I used Tombow Markers for color. It is a bit odd, but interesting all the same. The steps are below. Begin off-center and work outward from there.

This tangle is an original of Maria Thomas's called *Rain*. The background colors were applied by overlapping them. Copic markers—colors Y17 Golden Yellow (the darker color) and Y15 Cadmium Yellow (the lighter color). Any markers can be used, but these are great. Keep all markers capped when not in use.

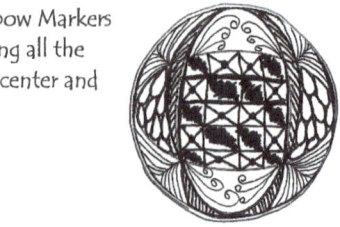

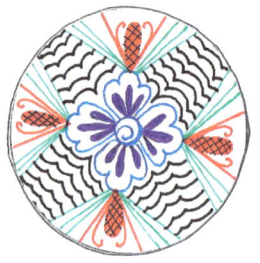 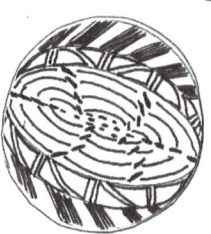 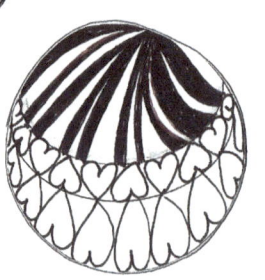 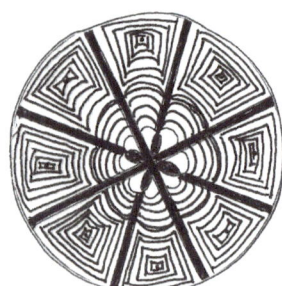

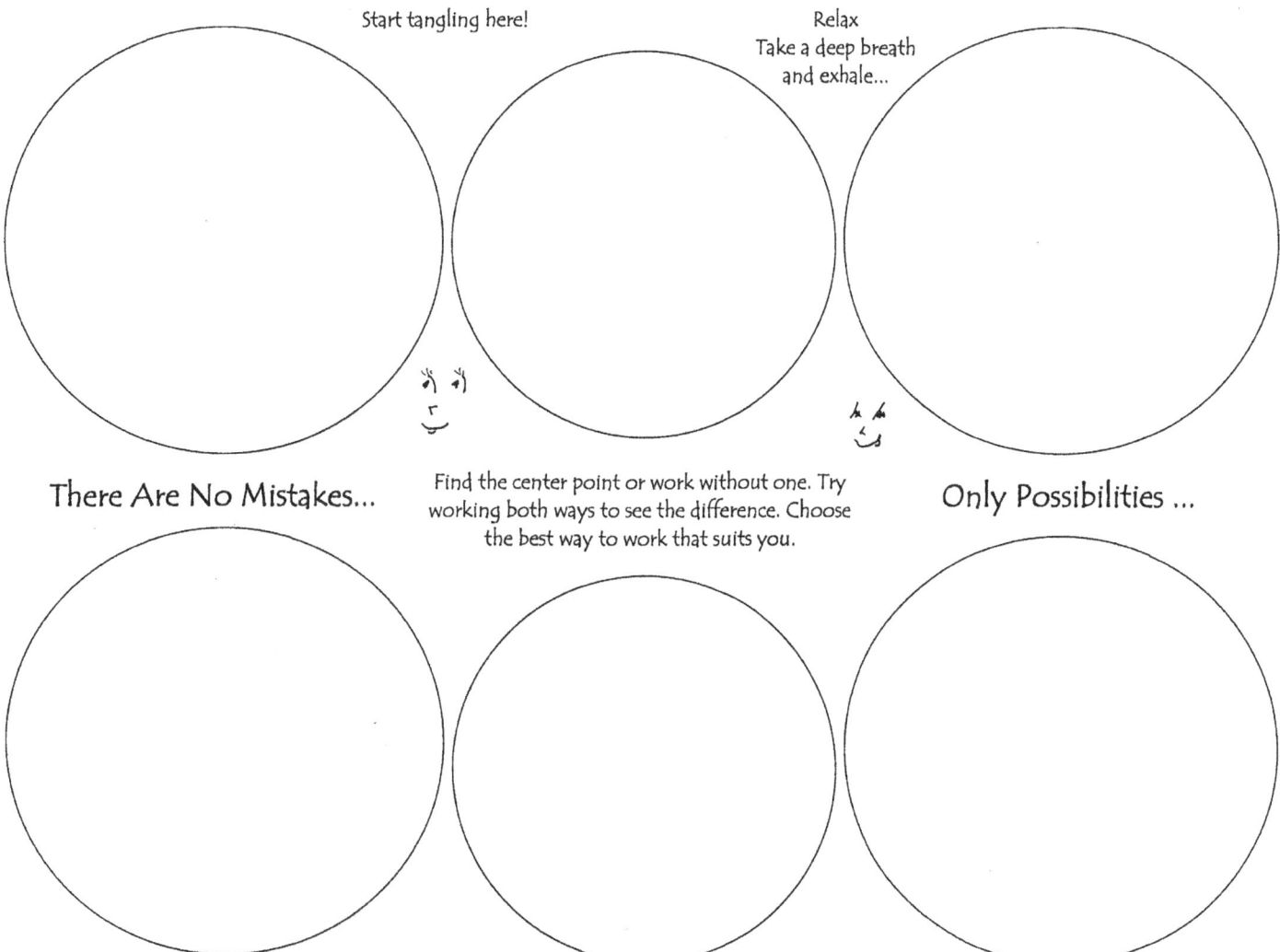

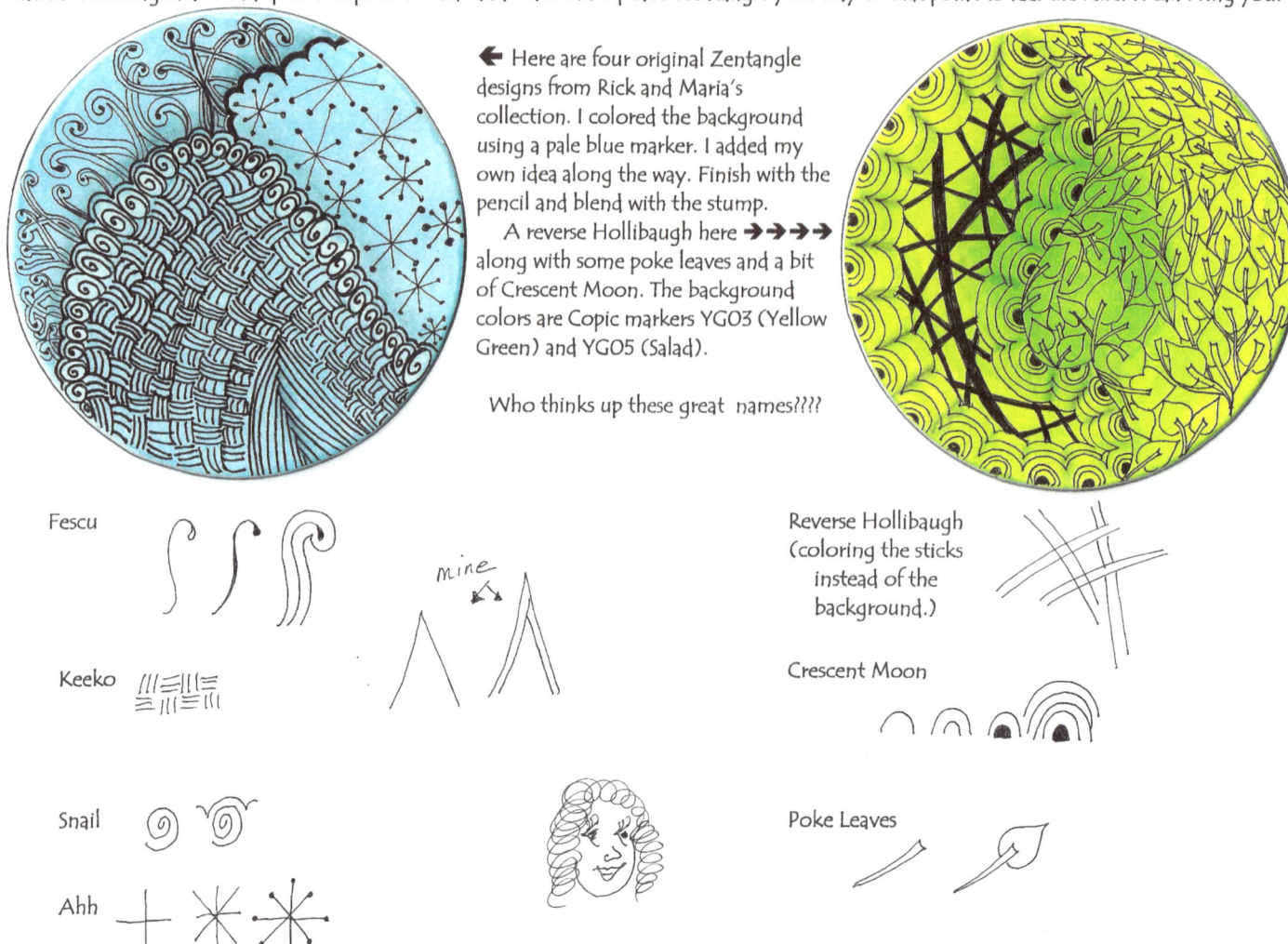

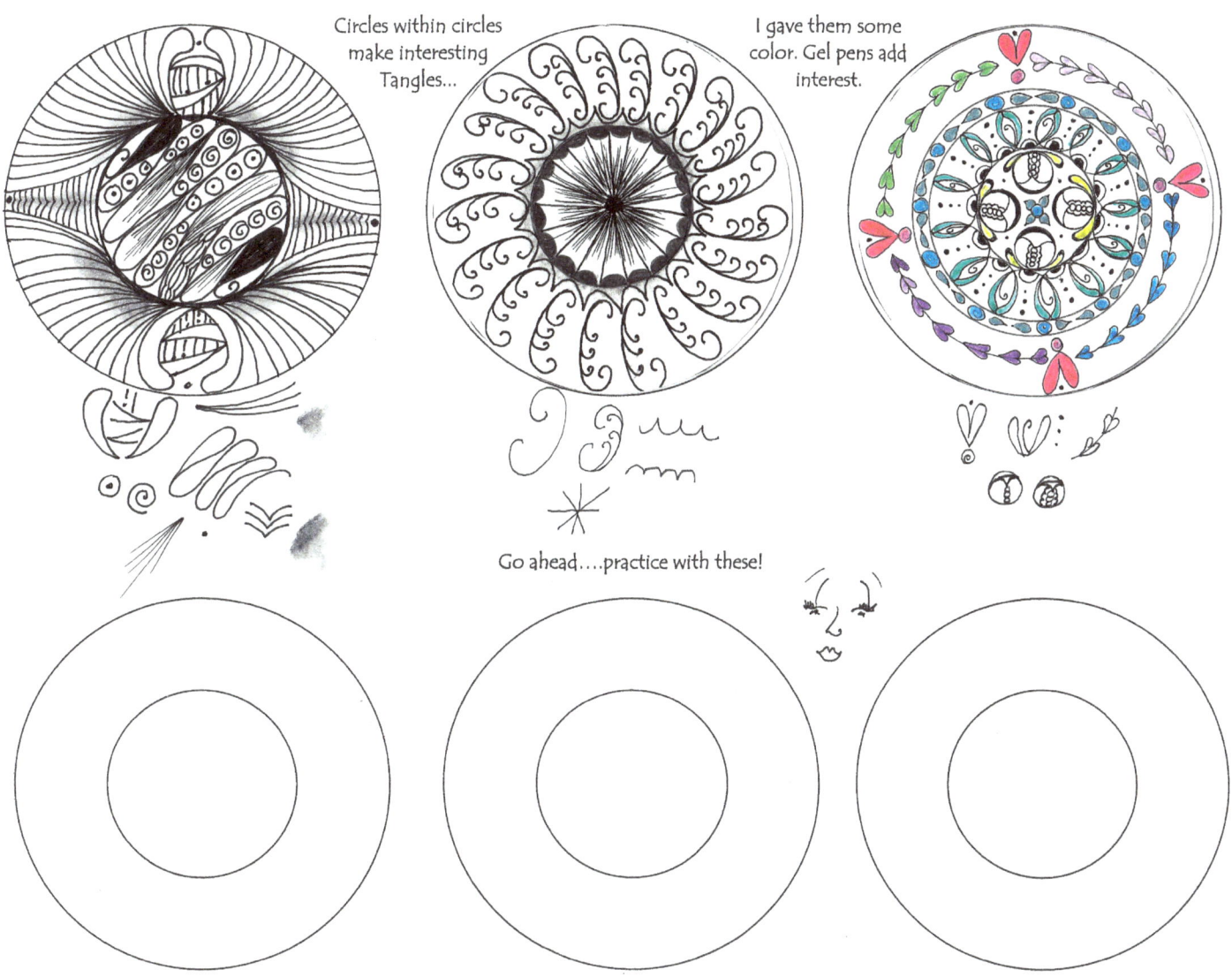

Ovals present a unique field for experimentation. Not only is the sphere rounded, but it's also elongated. By including color, these shapes create interest. Black and white is great, but color is also lots of fun. The shading was done using the pencil and blending stump to give depth and dimension to the designs.

Template shapes and stencils offer greater control and can be found in any craft or office supply store. They last for years, so they are worth the investment.

The individual designs are below for you to try on your own tangles.

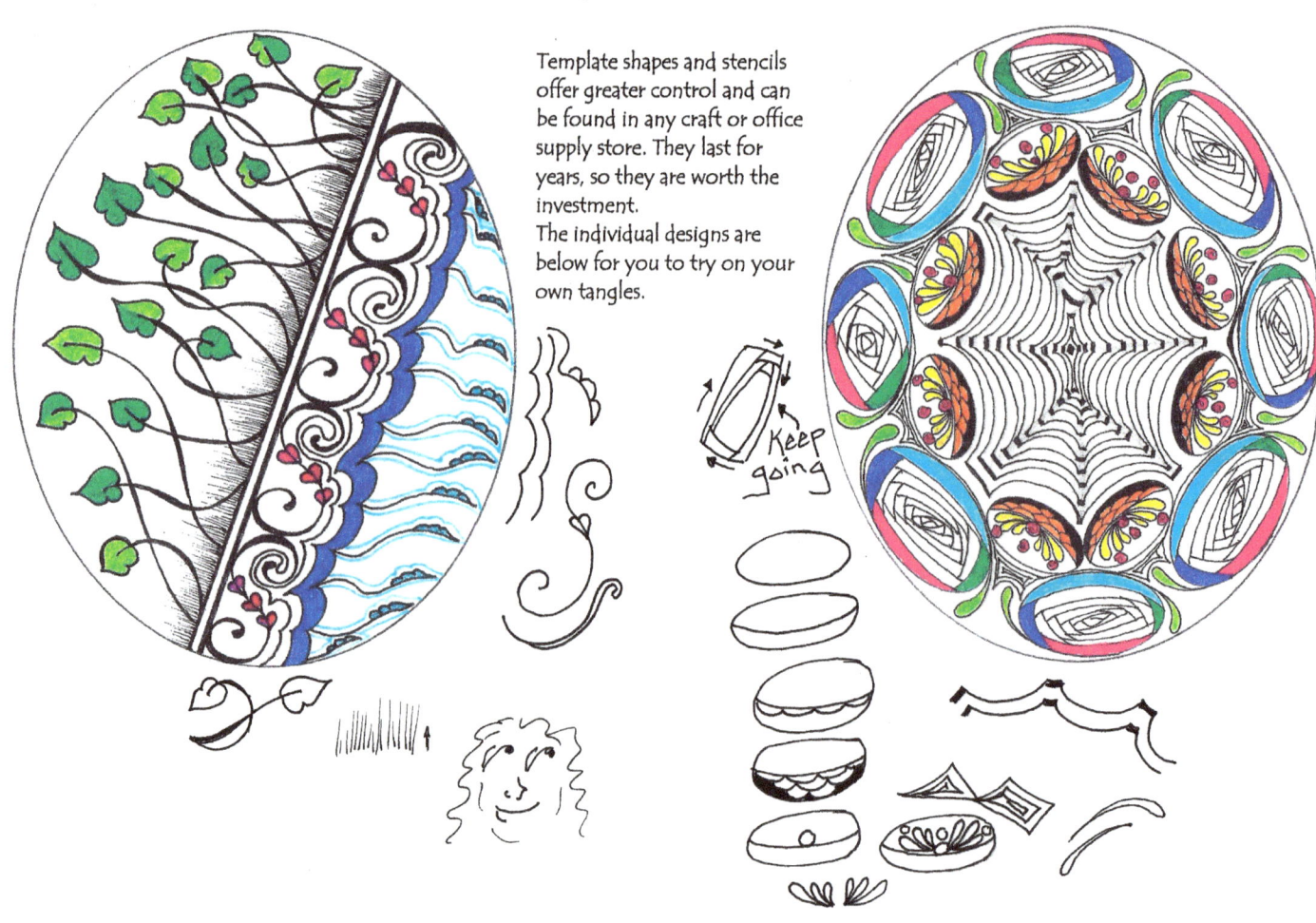

Color these in or make copies on a copier and then color them. Shade with the pencil and blend with the stump for added depth.

The patterns are on the following pages and are numbered for your convenience.

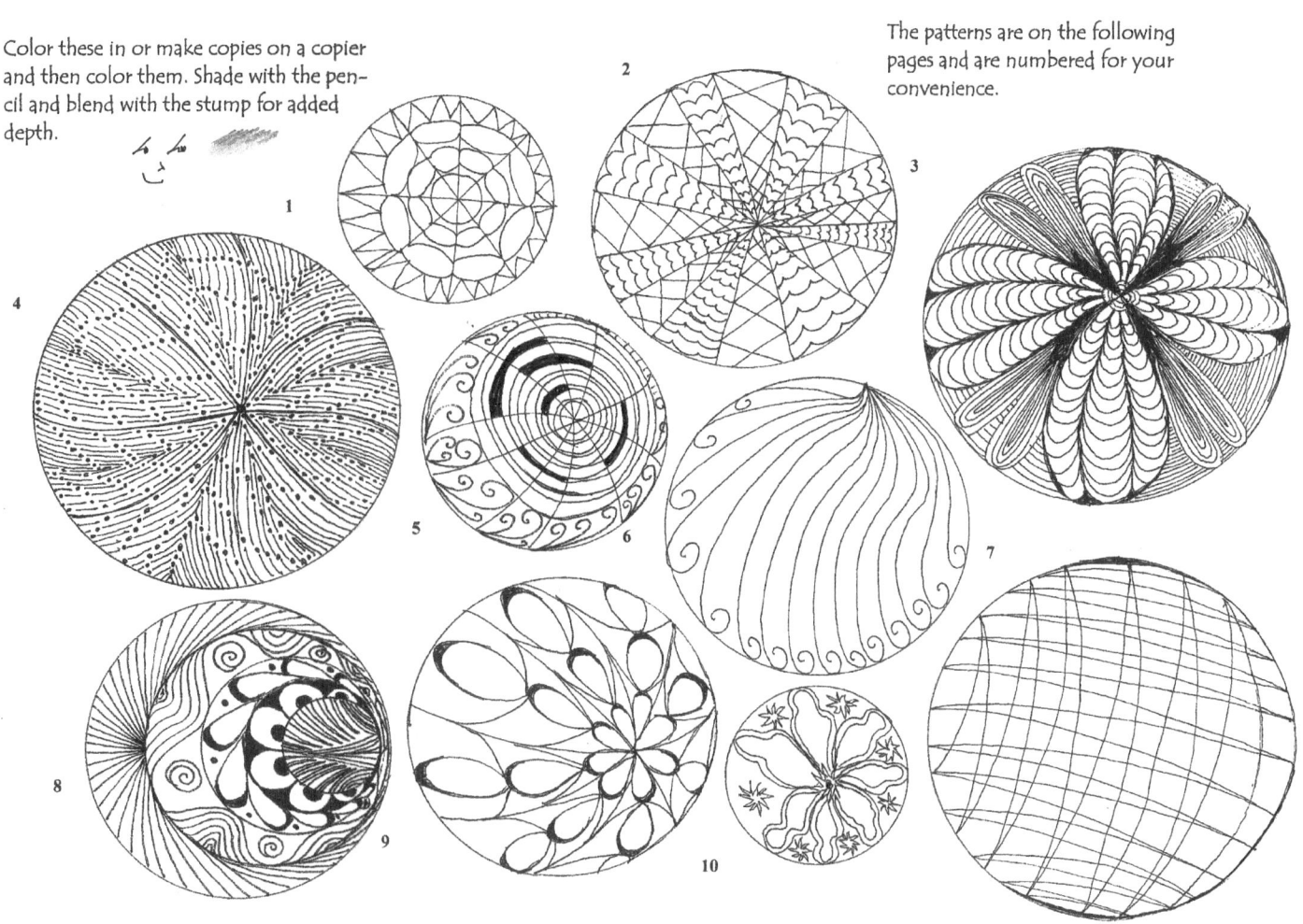

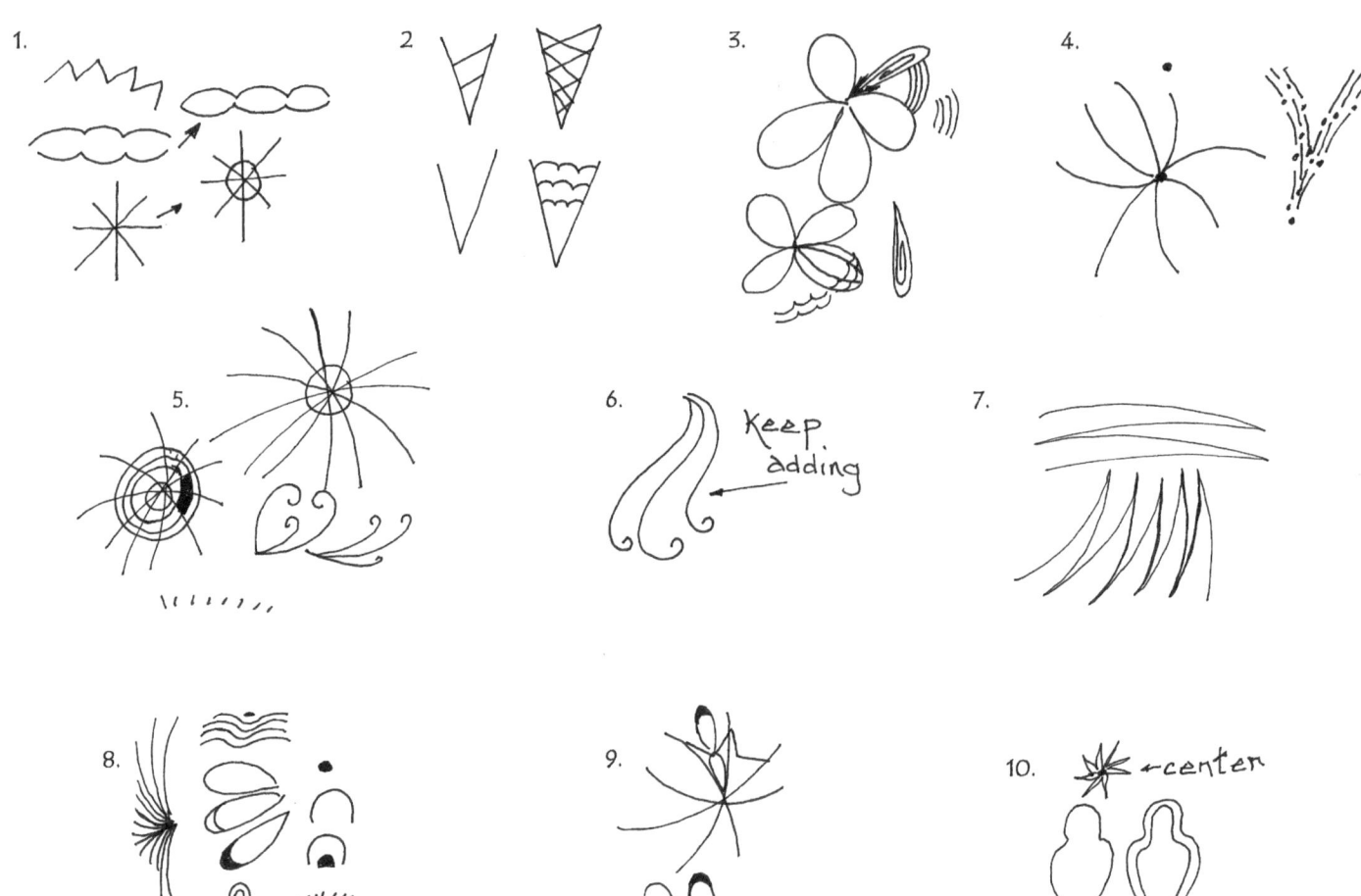

Centered or off-center, these were challenging. Ellipses and templates were used on some of them while others were done freehand style.

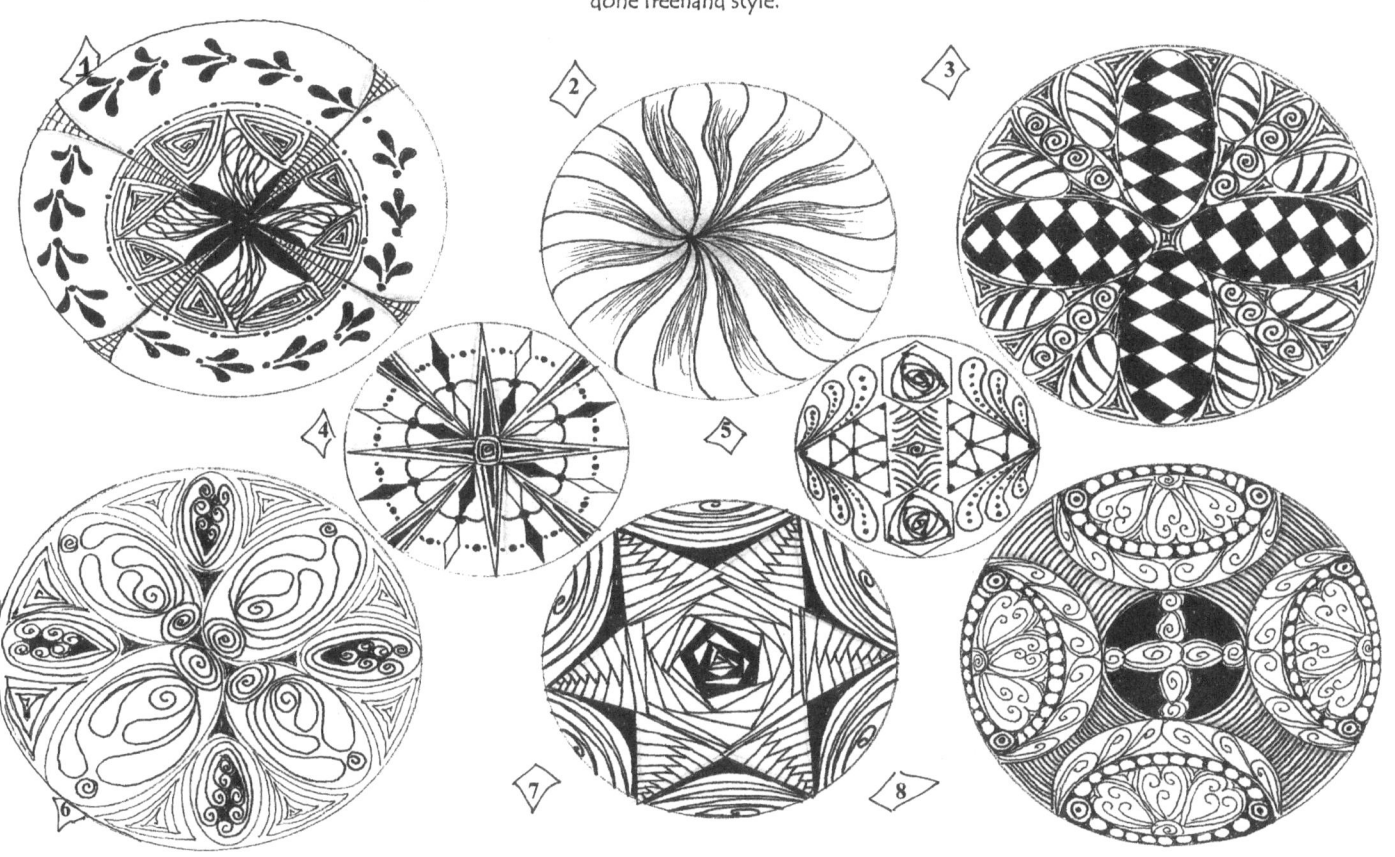

Design patterns are on the following pages.

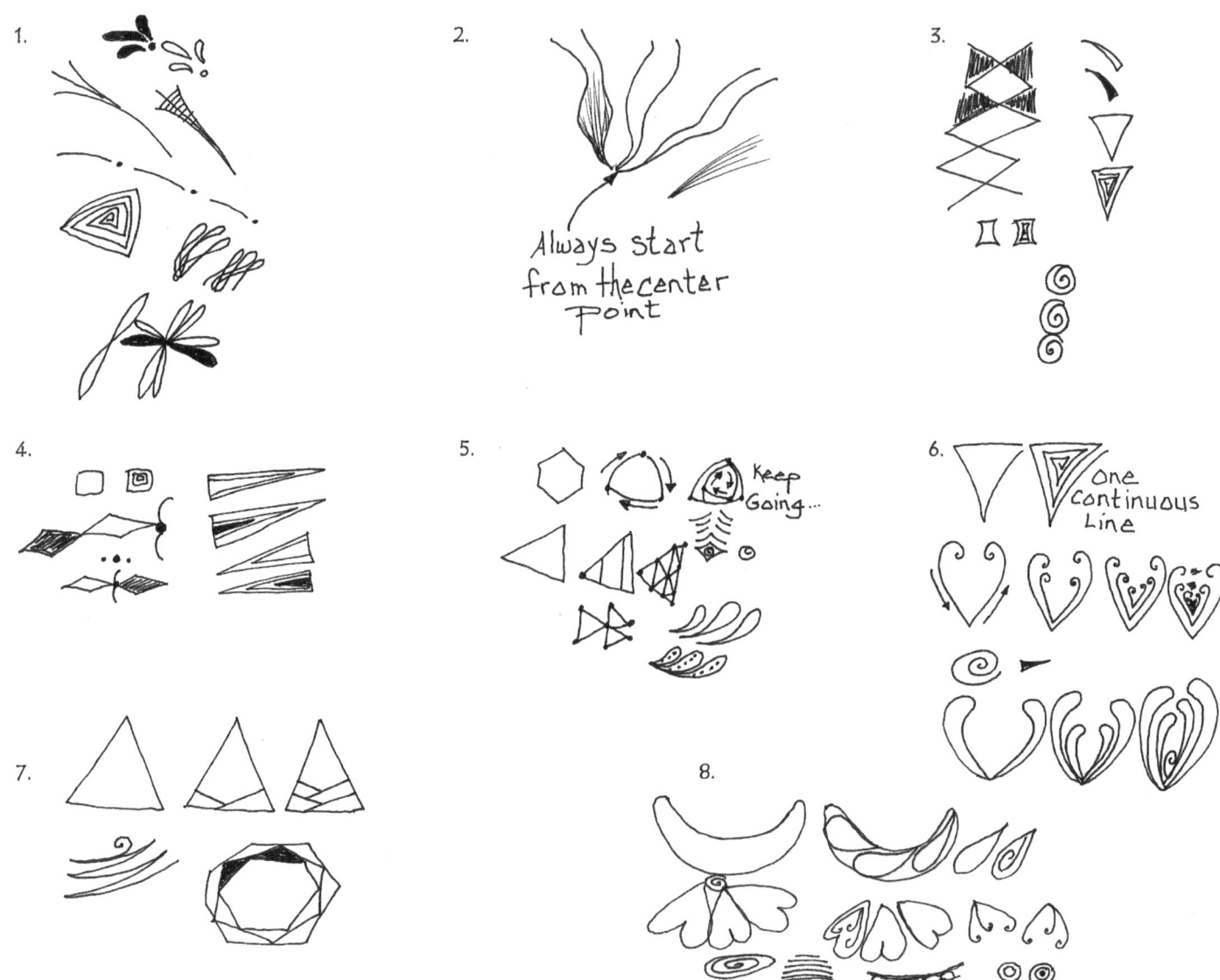

These two Christmas ornaments were first painted using metallic paints from Deco Art. The color was sponged on using a small sea sponge.

This ornament started out with four intersecting lines. From there, the triangles took shape.

Once the paint dried completely, a circle template was used to designate the inner circles on this one. Then the design was added using an 01 Micron pen.

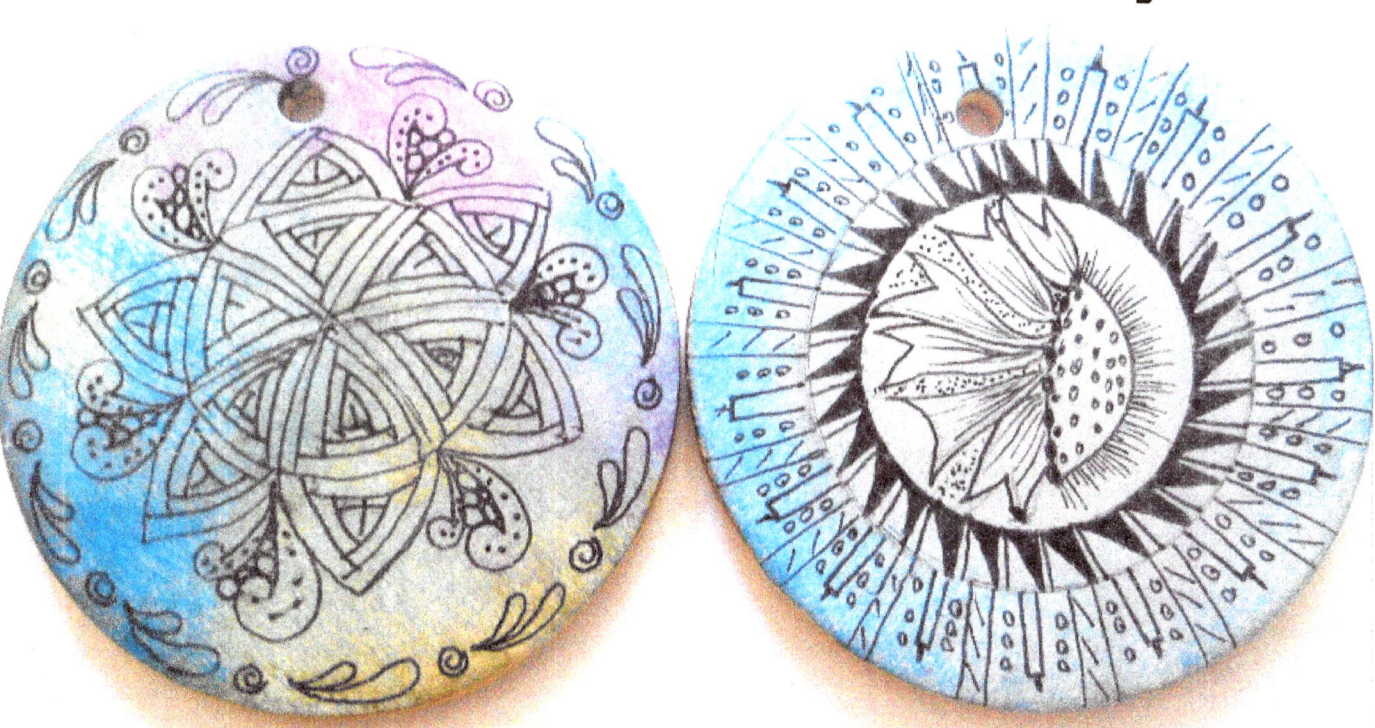

The surface is porcelain bisque. The material had been kiln-fired once, making the ornament Ceramic-like and absorbent.

These designs can be done on card stock, watercolor paper, paper mache, fabric....just think of the possibilities...

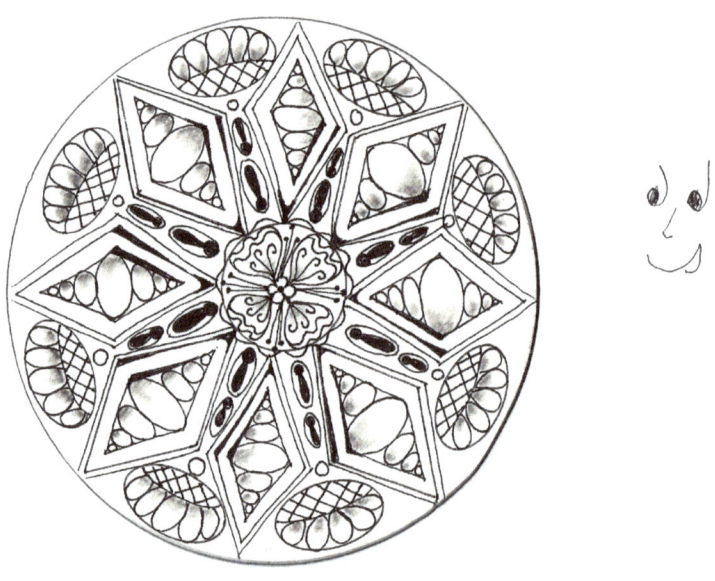

Diamonds, ovals and more....
Have fun with them!

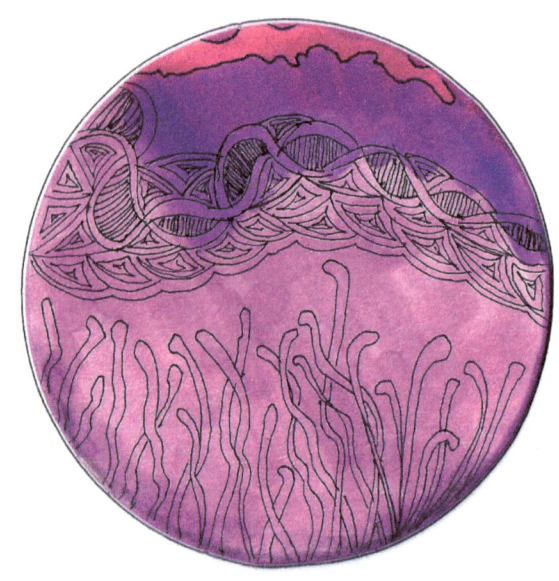

Great Wiggly Squigglies....
Colored background washed in dark and light purple.

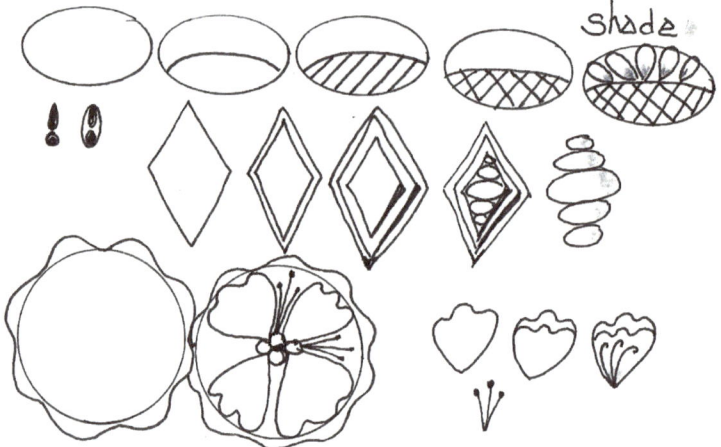

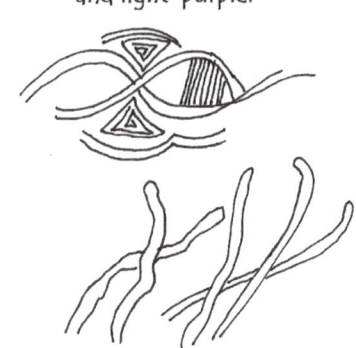

Light pink and light purple overlapping washes set the stage for this unique tangle. Sometimes less really is MORE...
Draw the lines and tangle within the areas where colors fade and darken. Shade with the pencil, or not...it is your choice.

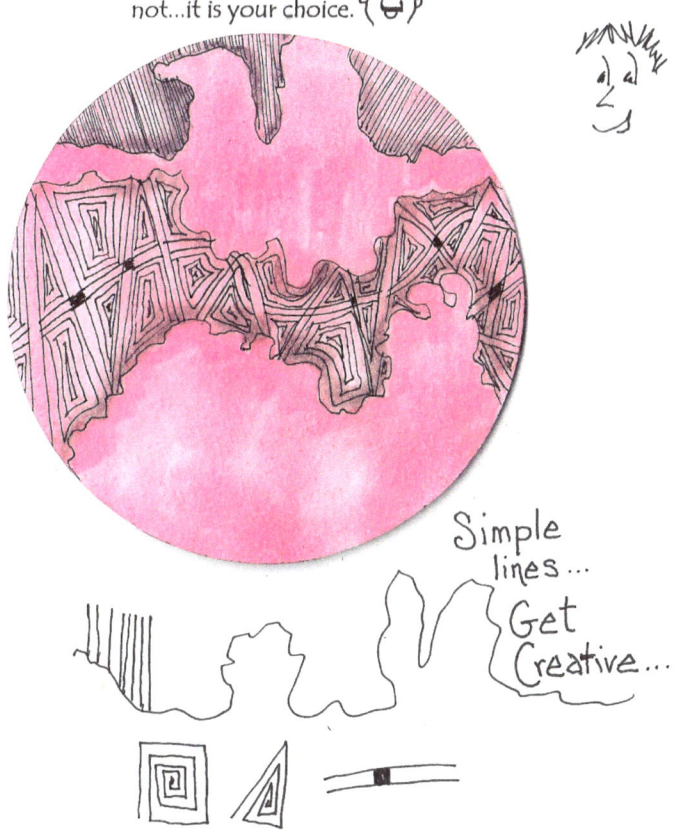

Simple lines... Get Creative...

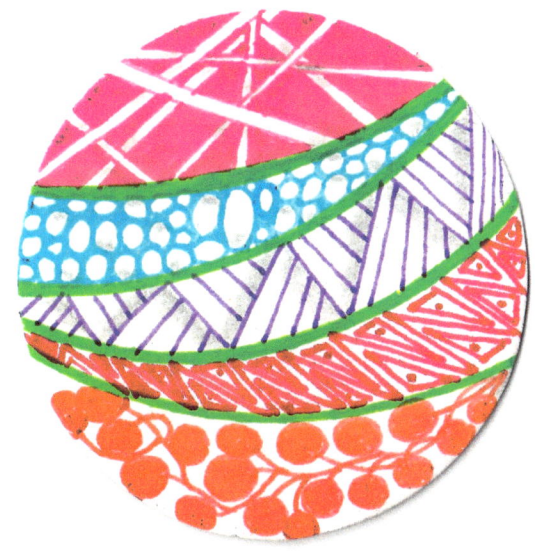

Colored with Sakura Glaze Gel Pens, this round was great fun. When the ink dried, shading was added using the pencil and blending stump.

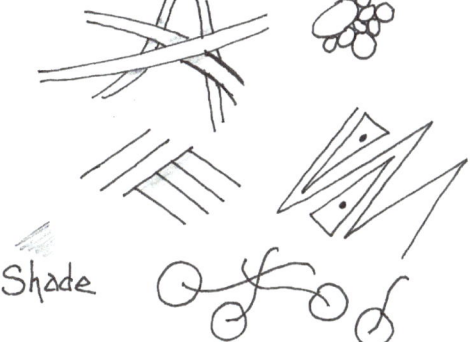

Shade

Breathe and reflect on what you've done so far.
If you're still tense, stand up, shake out your hands and arms. Reach for the sky and take a deep breath. Let it out and bend over at the waist. Extend your hands and arms downward and shake them out again. Stand up and breathe deeply a couple of times.
Now...let's tangle some more!

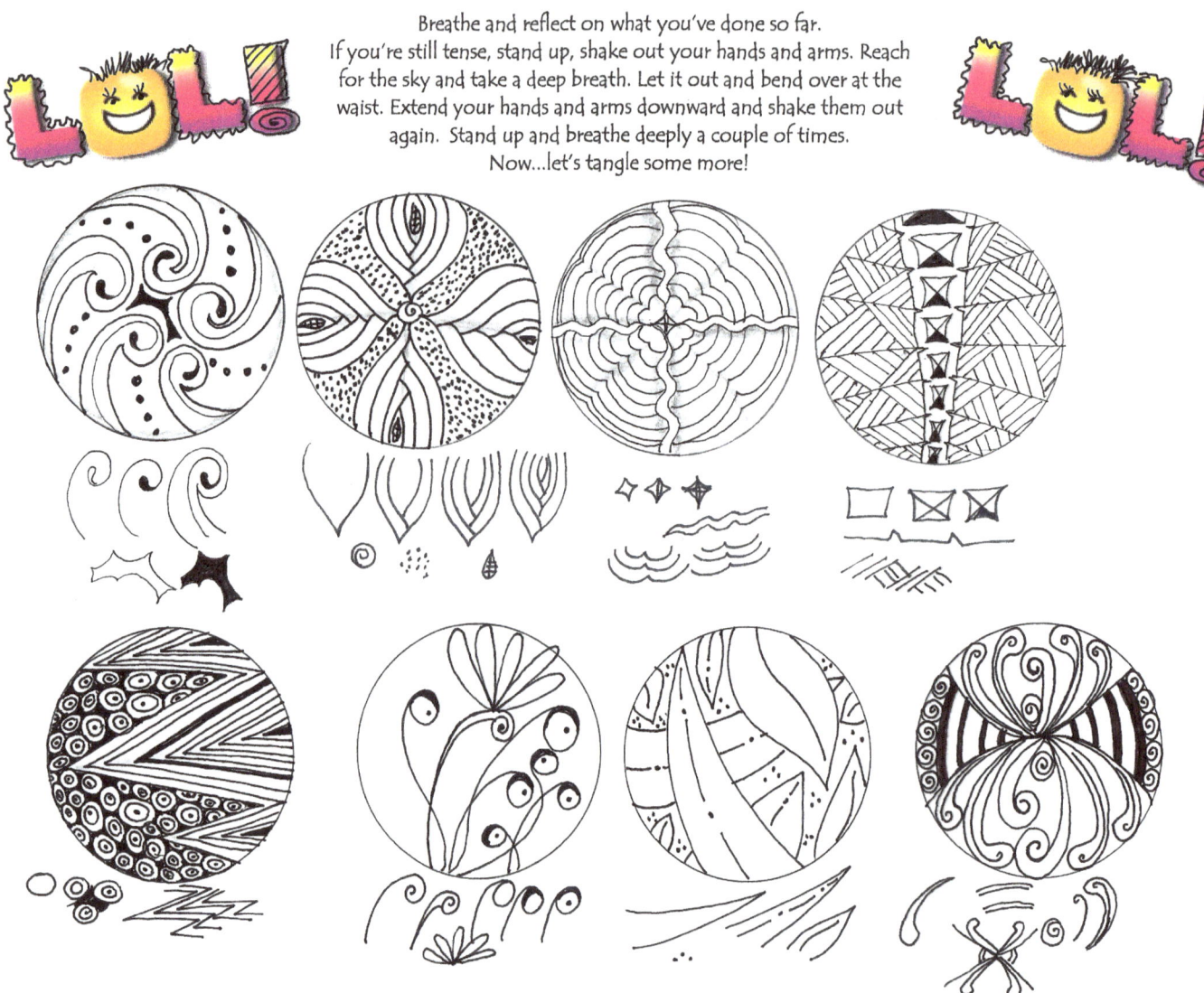

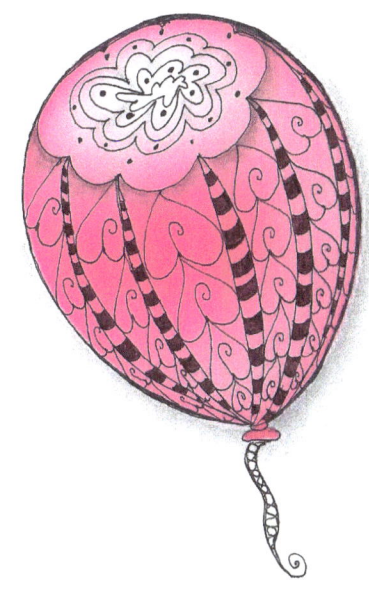
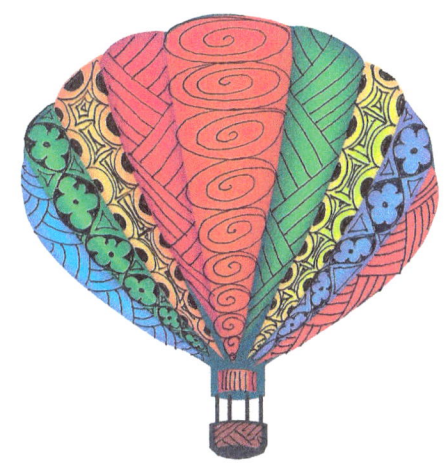
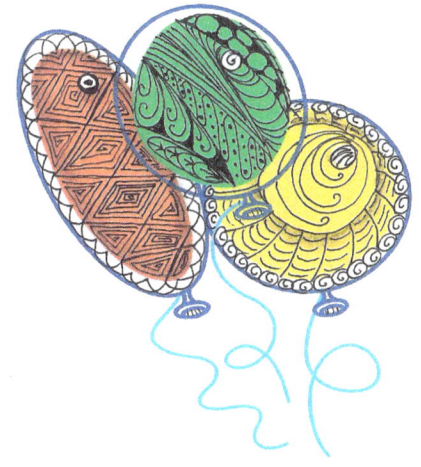

Balls and balloons are wonderful for tangling. See what you can do with these on the next page.

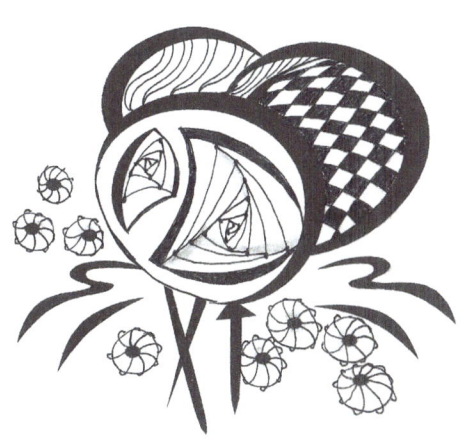
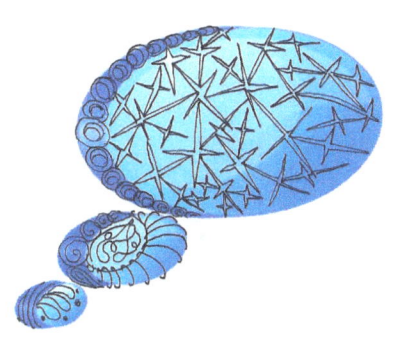
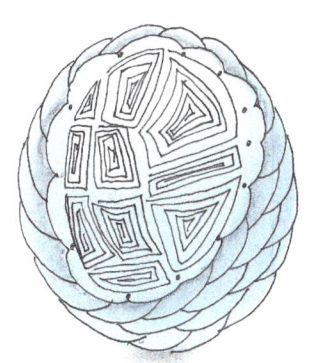

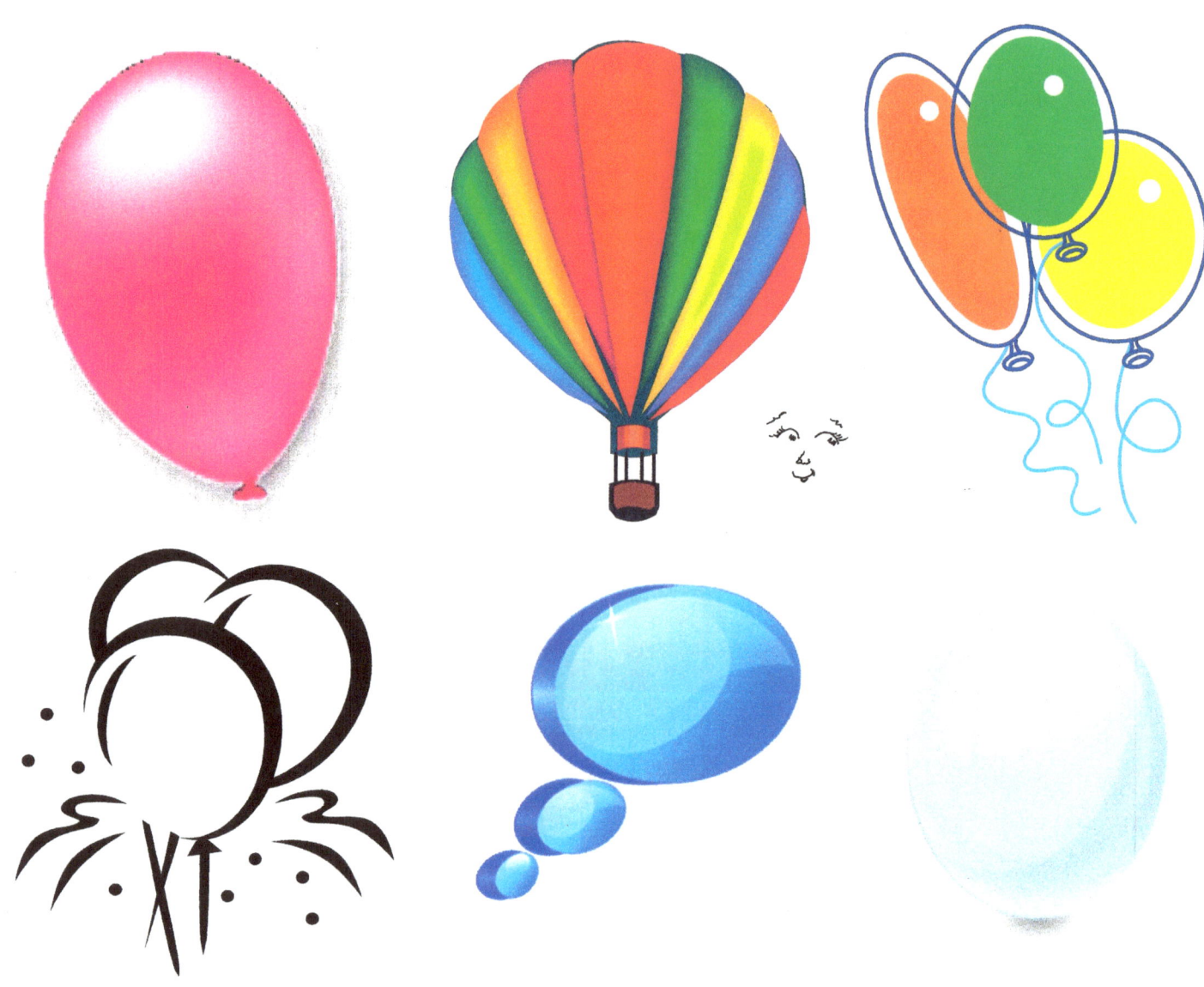

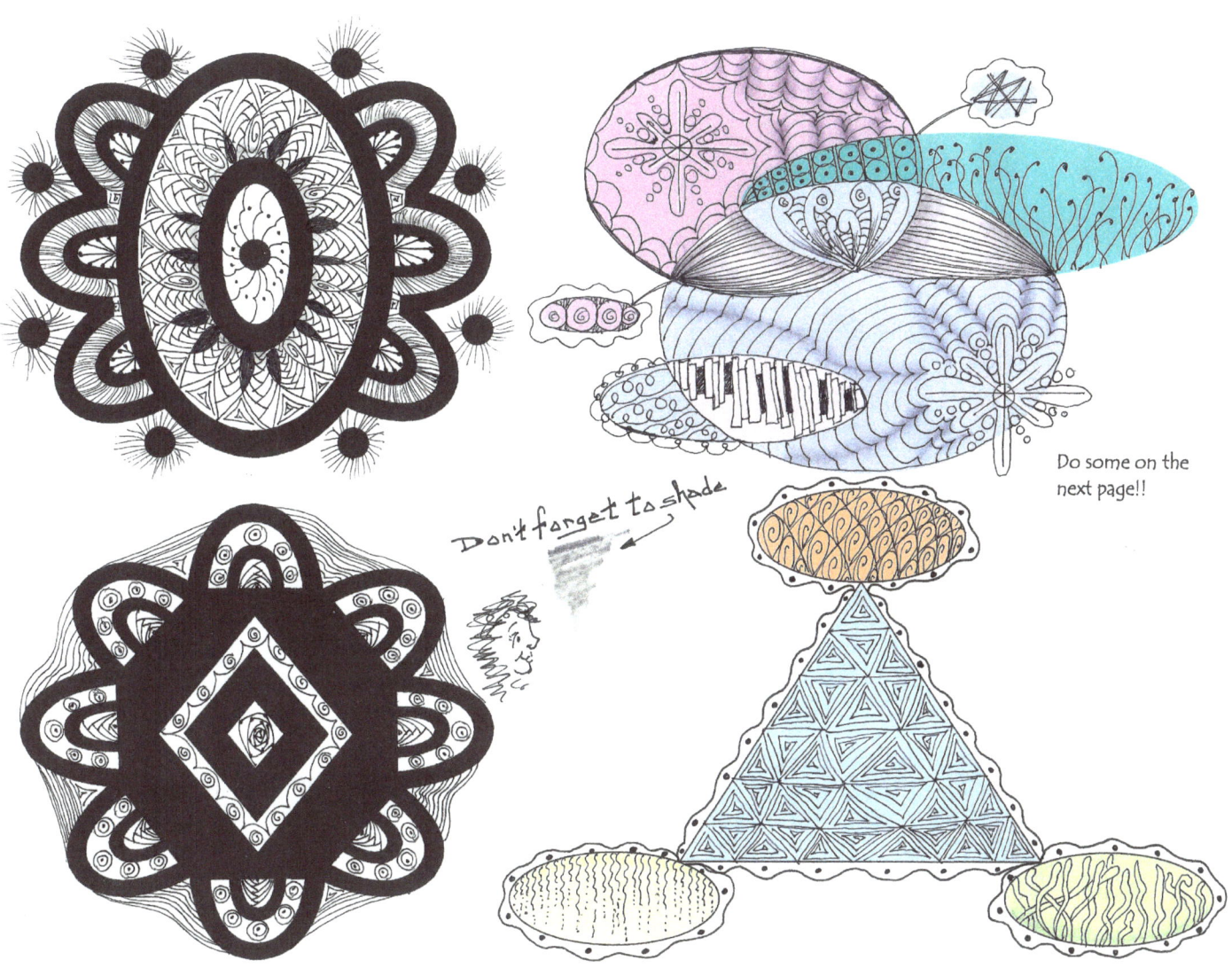

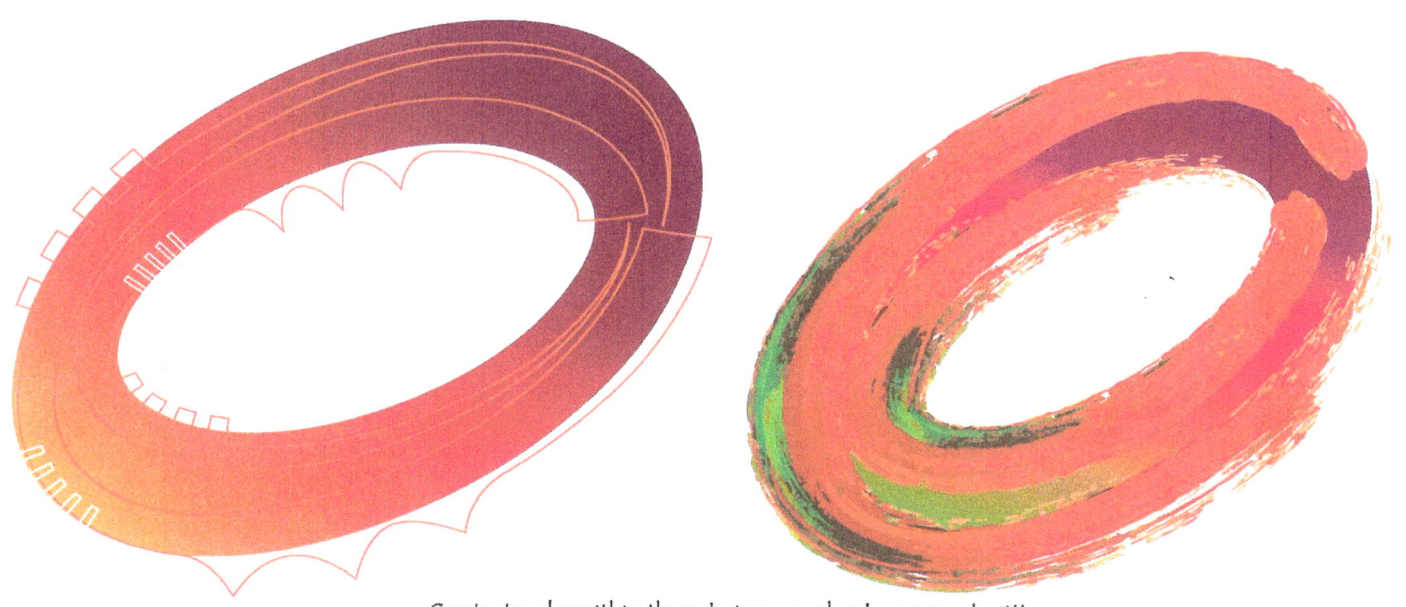

Create tangles within these designs. go ahead, you can do it!!

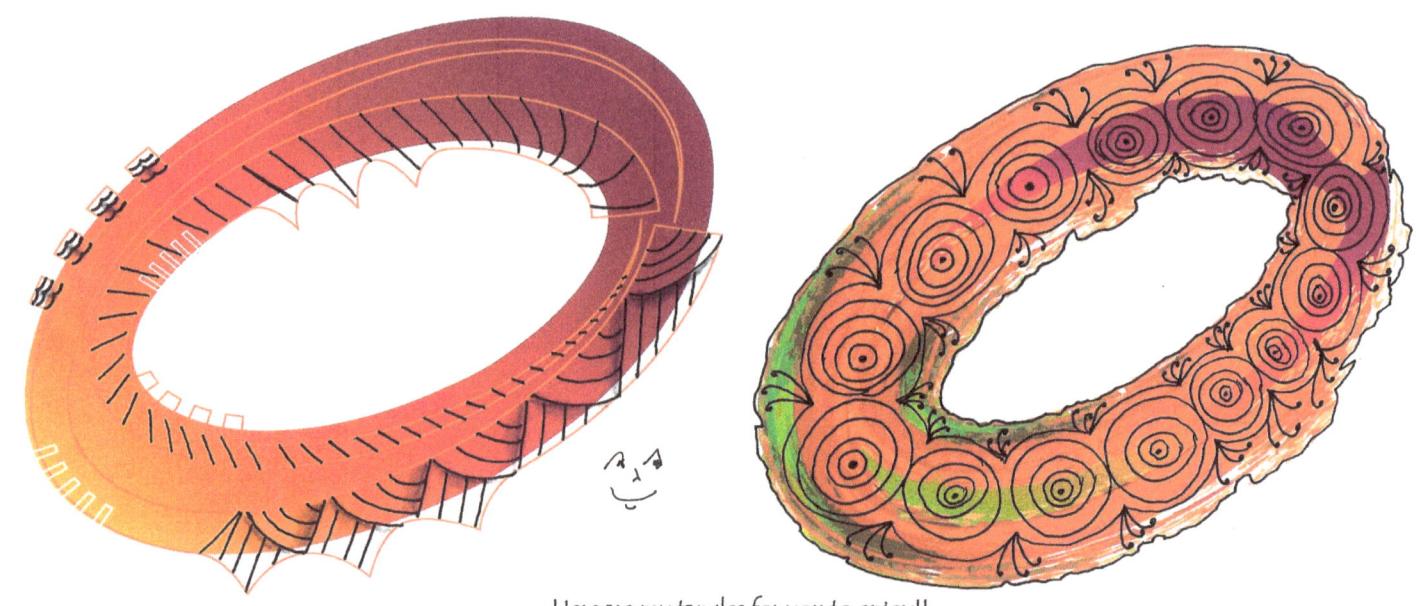

Here are my tangles for you to enjoy!!

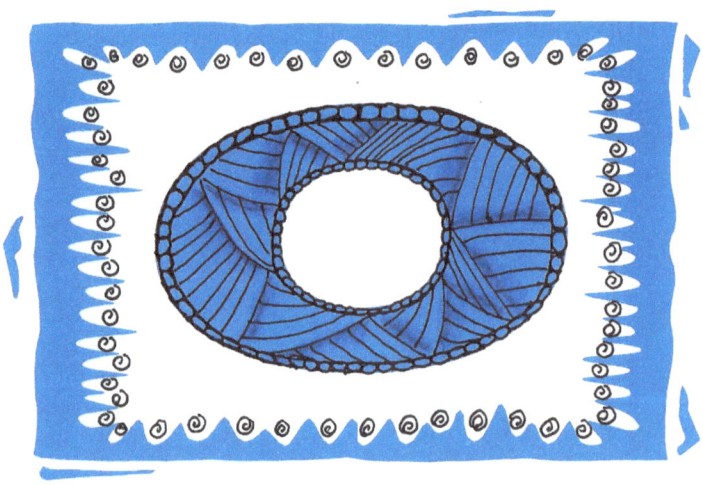
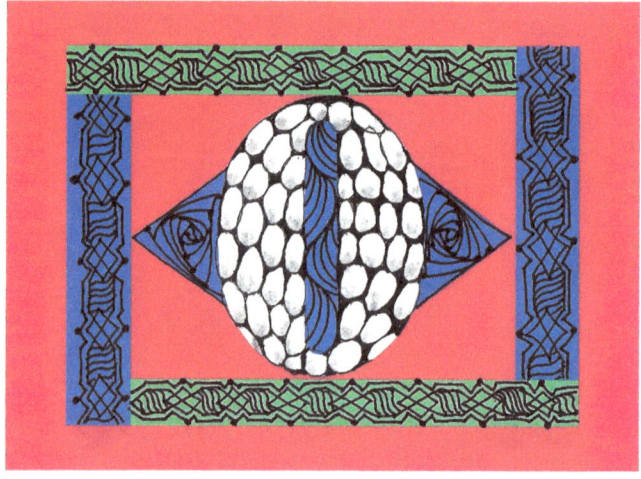

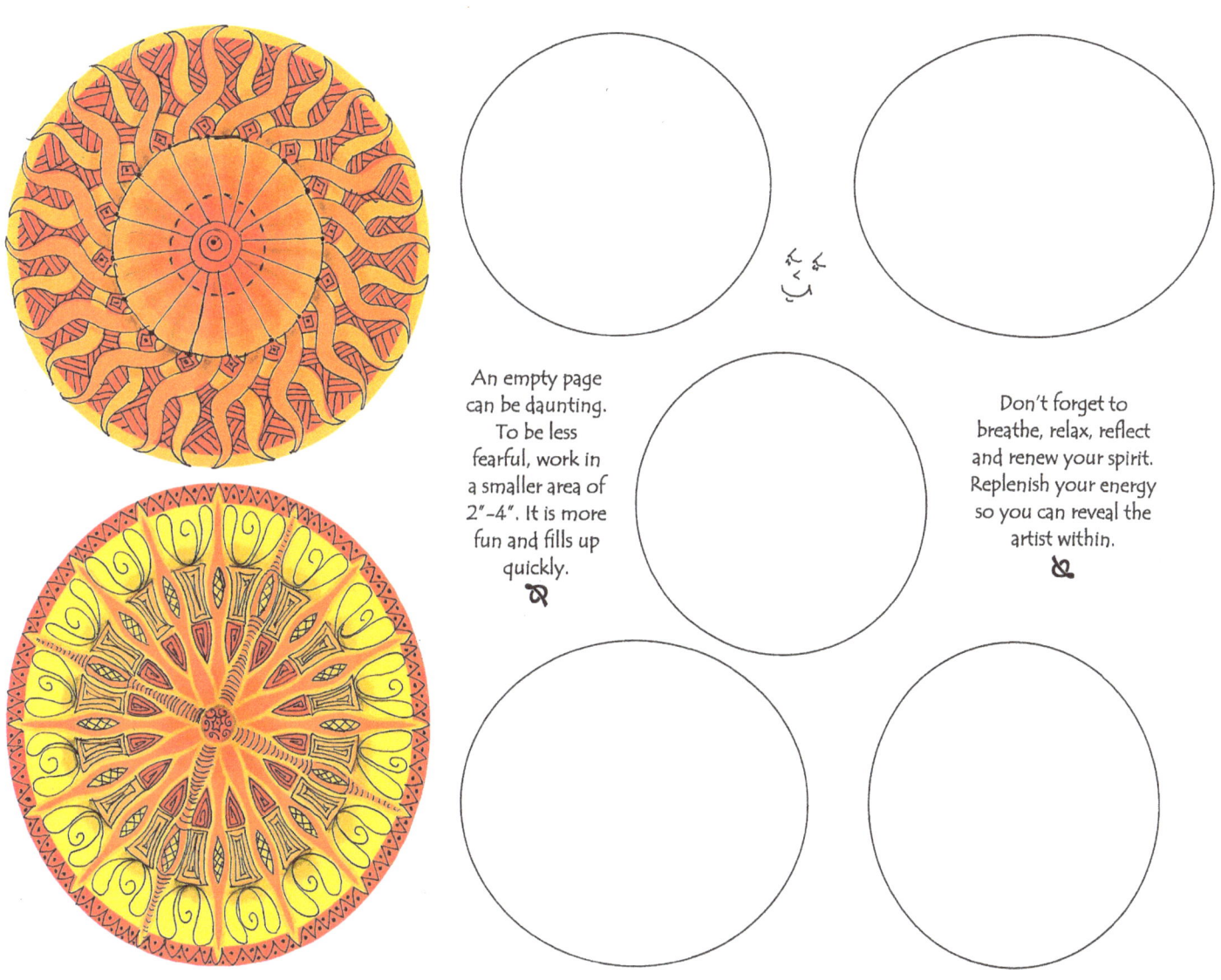

An empty page can be daunting. To be less fearful, work in a smaller area of 2"–4". It is more fun and fills up quickly.

Don't forget to breathe, relax, reflect and renew your spirit. Replenish your energy so you can reveal the artist within.

Remember the egg theory from page 2 if your hand becomes stiff and cramped. Shake your hand, flex your fingers, relax your muscles and let your tendons rest a while. Get up and walk around. Breathe deeply and most of all ~ RELAX...

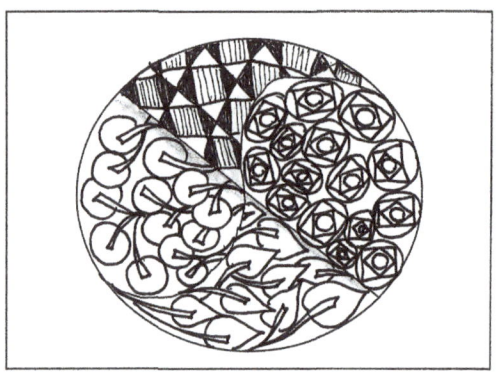
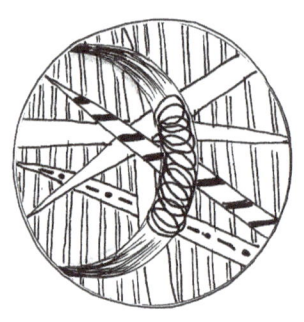
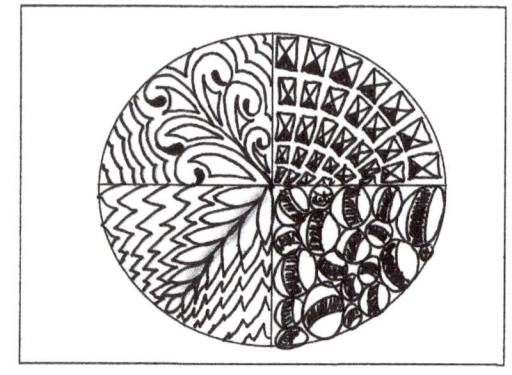

Put Yours

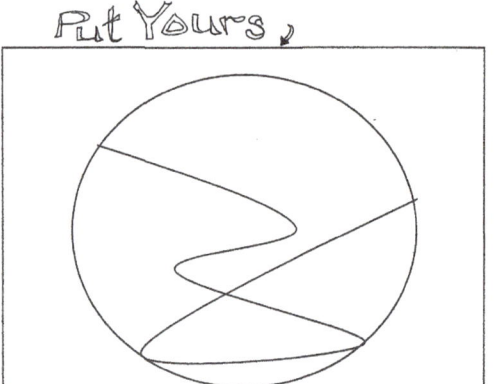
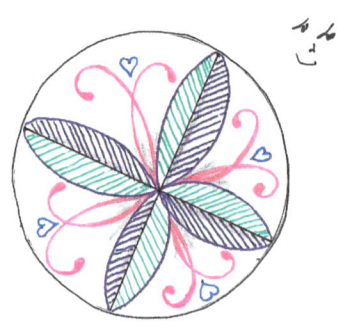
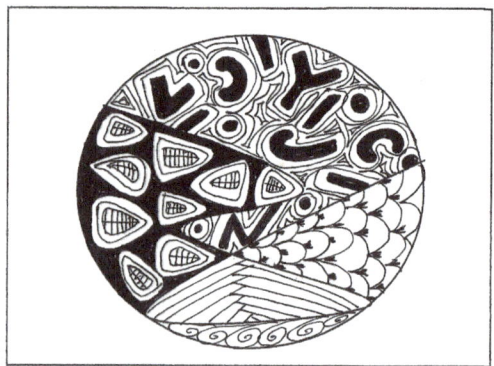

Remember the egg theory from page 2. Now that you have RELAXED... let's tangle some more. Work out your tangles using some of the designs offered within these pages or invent your own. As Maria Roberts says, "All things are possible one stroke at a time".

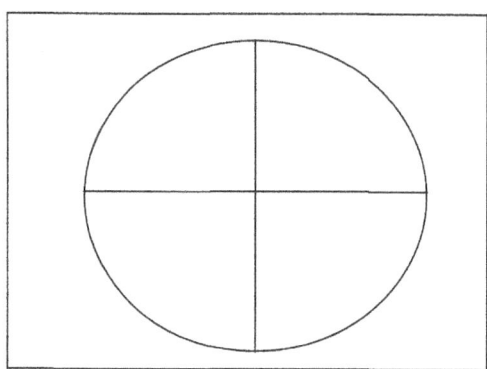
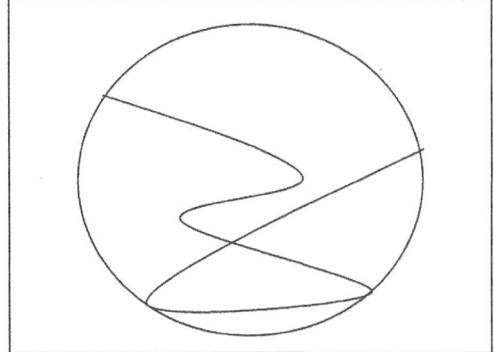

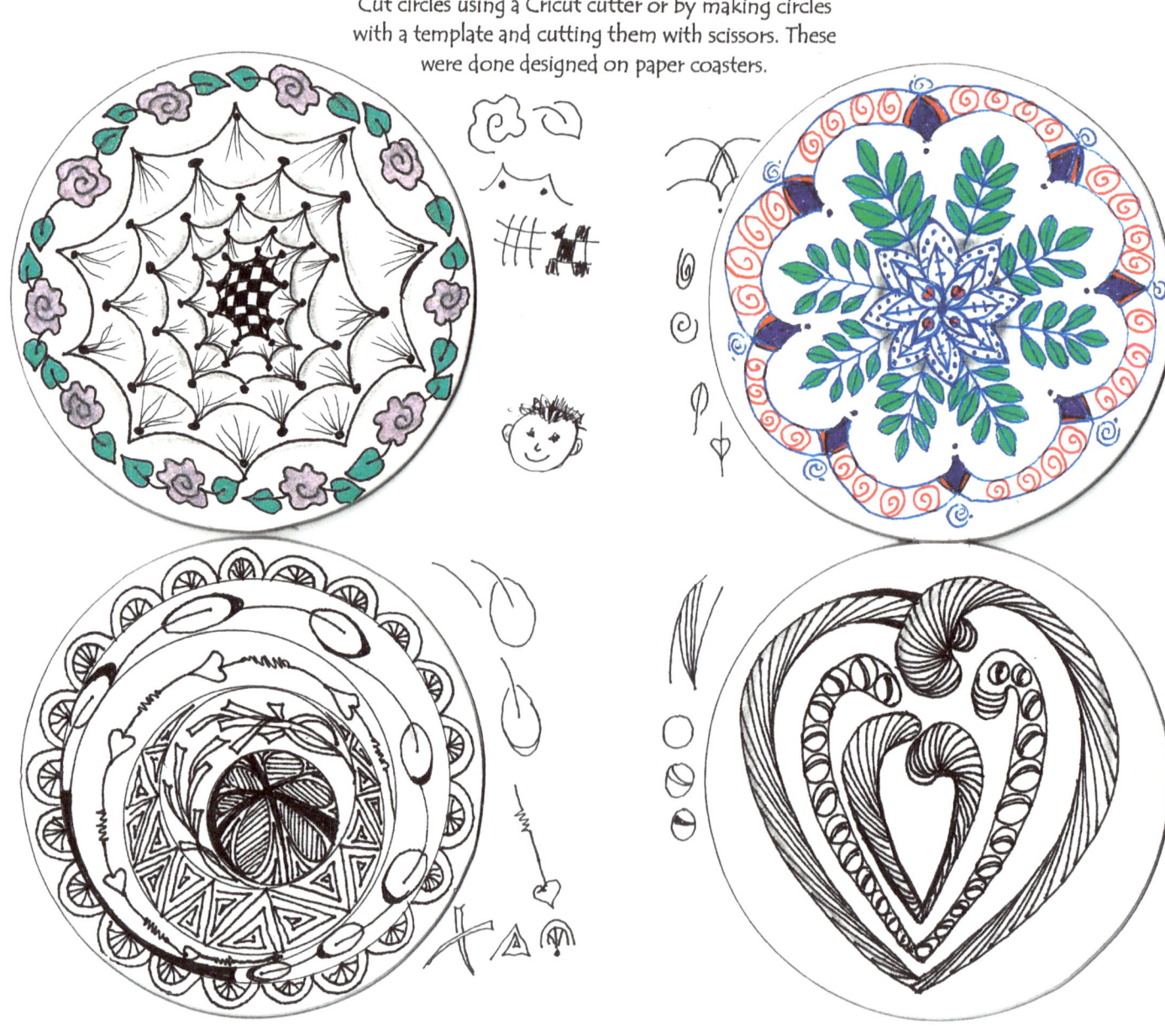

Cut circles using a Cricut cutter or by making circles with a template and cutting them with scissors. These were done designed on paper coasters.

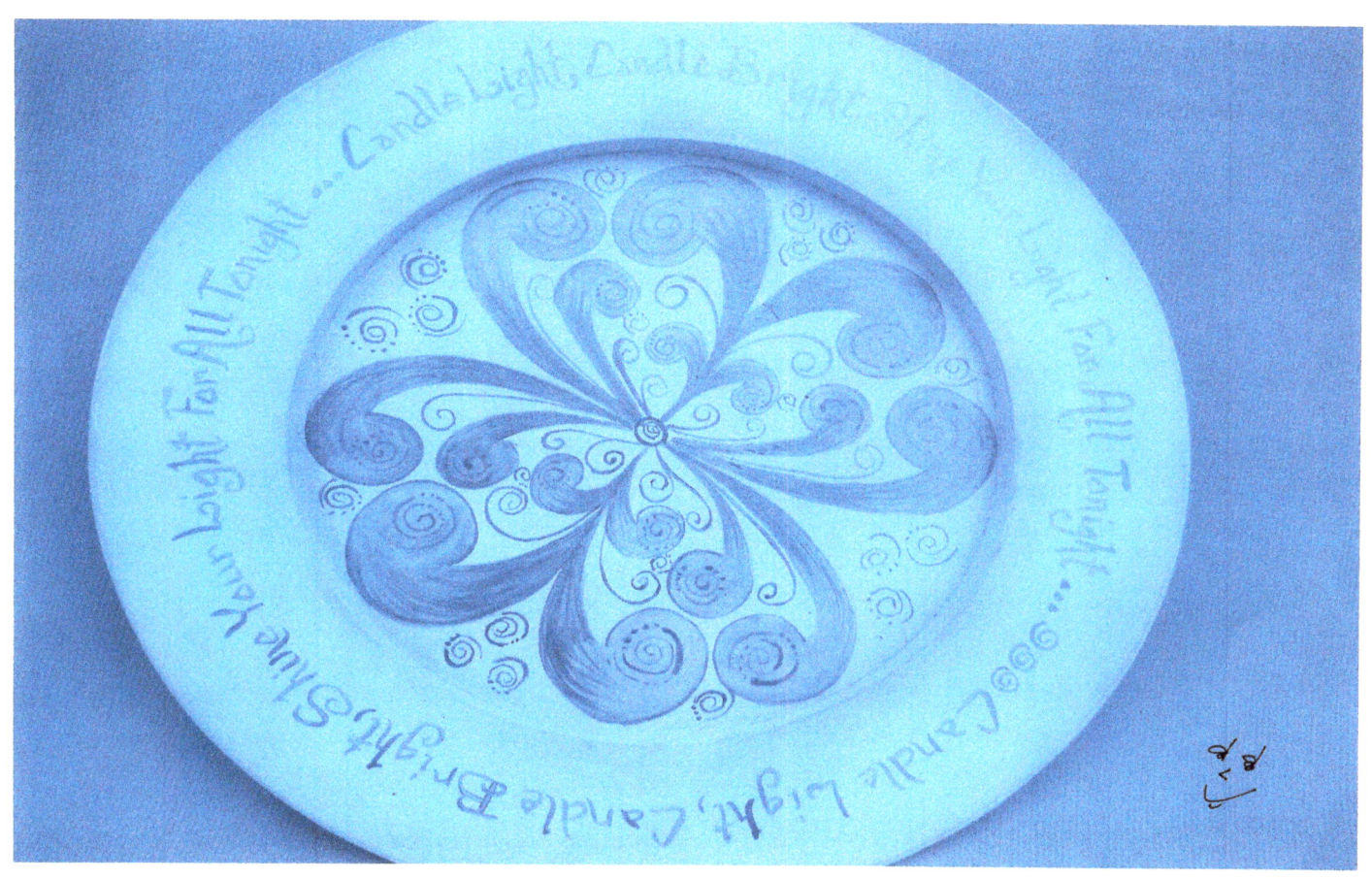

Comma designs on this candle plate were achieved using a fine tipped pen. The background was first painted pale lavender and shaded with a darker lavender. Starting in the center with a small swirl, I extended the commas from there, each one growing in size. Color was applied inside using markers. When the ink dried, line work was added with glitter gel pens. Lettering was done with a #1 liner brush, but could be done using a fine tipped calligraphy pen or plain gel pens. Use your imagination when it comes time to design your own gifts. I purchased an inexpensive straight glass chimney that has a hook to hold the candle so the design can be seen as the candlelight glows.

Put a little sunshine on a greeting card to let the recipient know how you feel. Tangle the interior after coloring it. Cut it out and paste it in place. What a neat idea!!!

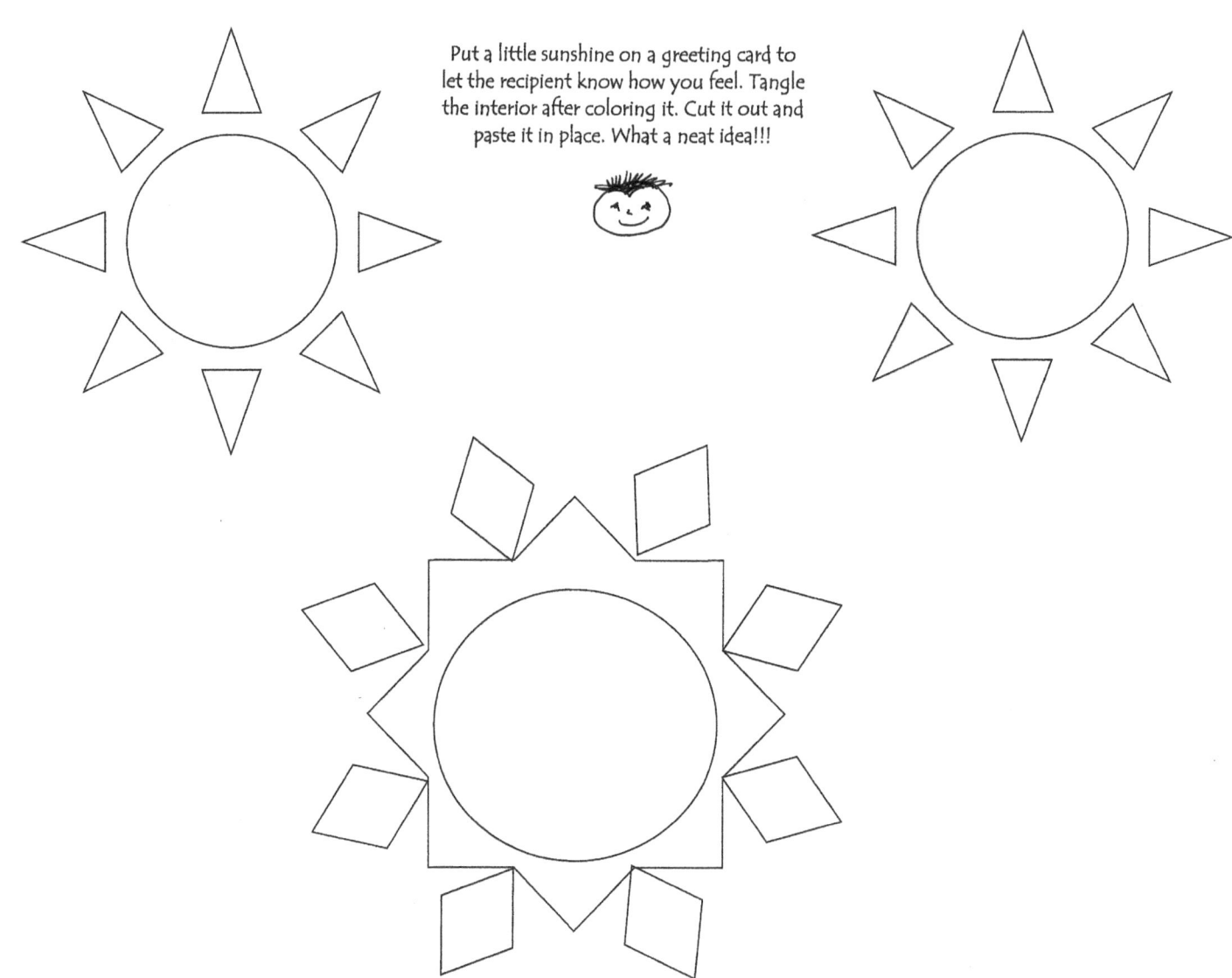

Replenishing your energy is important when keeping your spirit renewed and your body & mind relaxed. Zentangle daily, even for a short period of time to help maintain these important factors in your life. Tangling is great for all ages from children to retired adults and everyone in between. Keep in mind "There are No Mistakes....Only Opportunities" as you make your way through your own Zentangle Journey. Whatever shape you use, enjoy the art of tangling and remember to breathe and relax. ♥

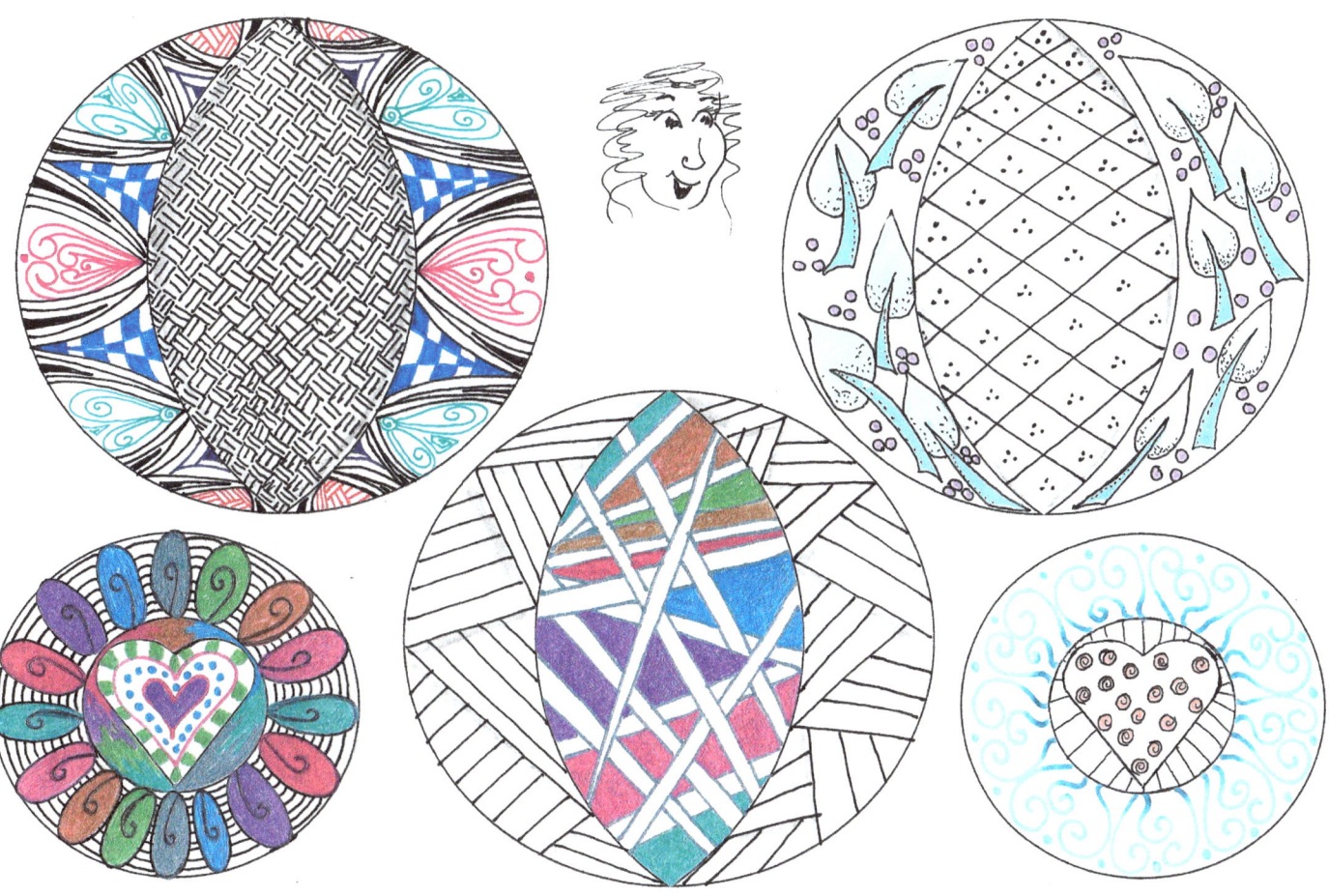

"There are No Mistakes....Only Opportunities"
Enjoy the art of tangling and remember to breathe and relax. ♥

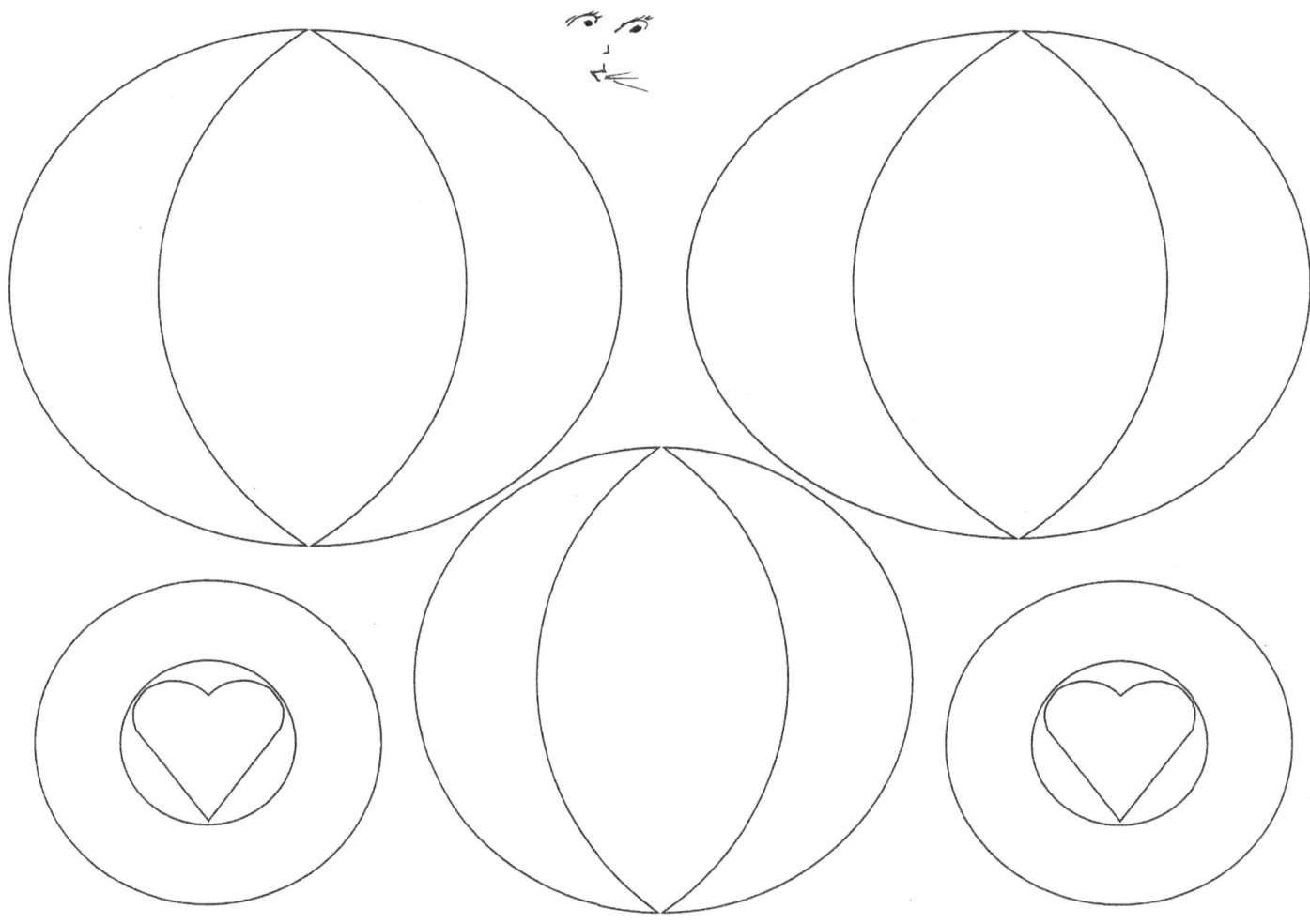

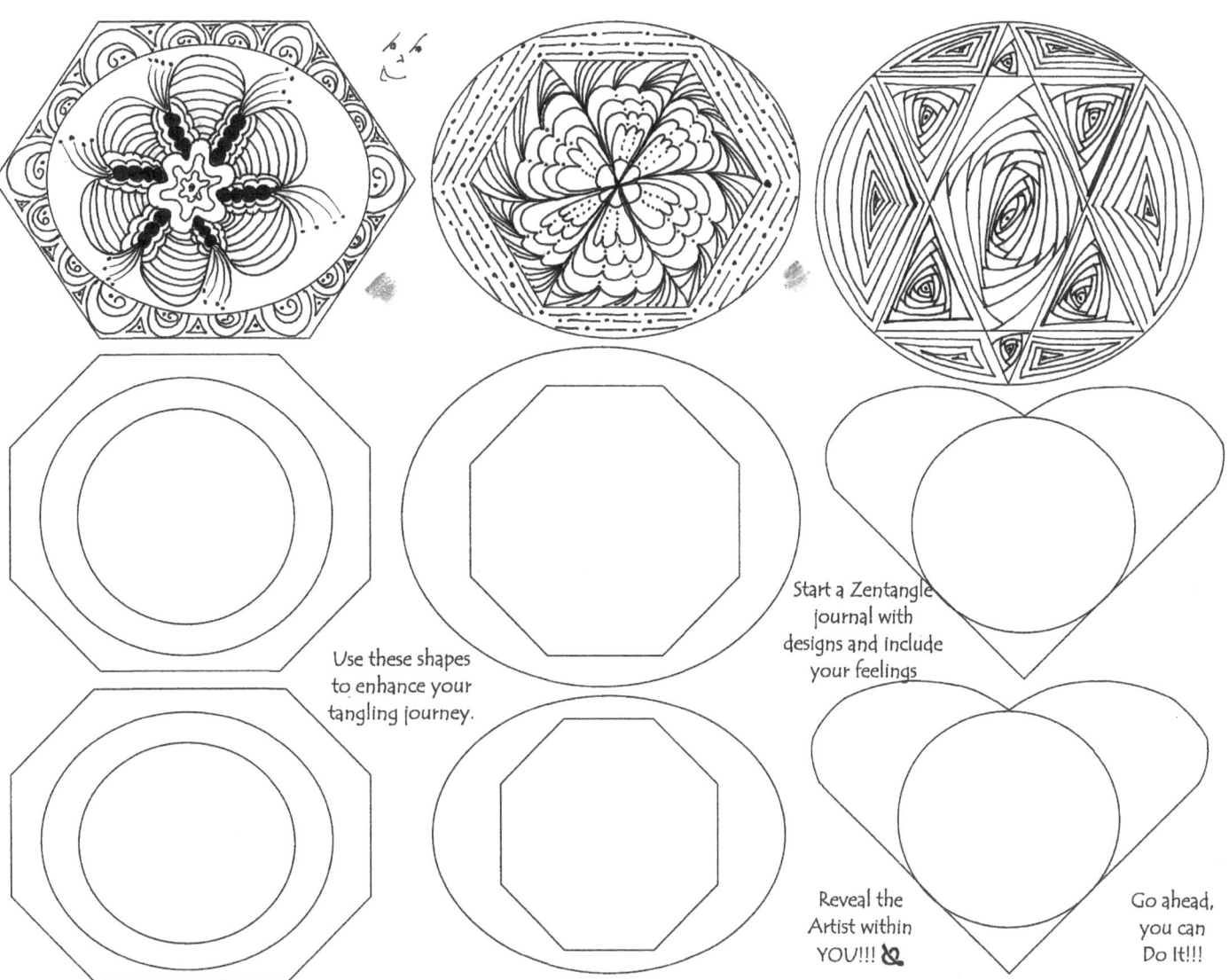

Reveal your Artist – Self

Jeanne Paglio began her art career over 30 years ago. She has been published in art magazines and her greeting card designs have been licensed. Jeanne stumbled upon an article by Sandy Steen Bartholomew in the Cloth Paper Scissors magazine a few years ago. Immediately Jeanne knew she was hooked on this art form. While waiting for the opportunity to take a certification class (they fill very quickly), Jeanne took classes from local RI CZT's.
After a week long class with Rick Roberts and Maria Thomas, Jeanne got her CZT certification under her belt. That was when Jeanne knew there were no boundaries for this delightful art form.

Jeanne's next book in the Zentangle series will be *Zentangle ~ No Boundaries*
Look for it at www.Amazon.com on February 1, 2012
and on Jeanne's website www.DecorativeArtistry.us

Zentangle ~ No Boundaries

Book Overview:

Jeanne will walk you through the steps of creating easy home décor pieces and gifts, light and fun greeting card designs, and marker lettering using tangled letter examples. You will learn basic tangles that will lead you to those more intricate. No need to fear, there are always spaces to work in Jeanne Paglio's Zentangle workbooks.
Remember…
"There are No Mistakes…Only Opportunities"

Be healthier, energetic, less stressed, and develop greater focus to become more productive by tangling everyday.
You <u>CAN</u> do it! "OOPS" moments are easy to turn into opportunities.
Have fun tangling, and watch your enjoyment of this wonderful artful experience grow.

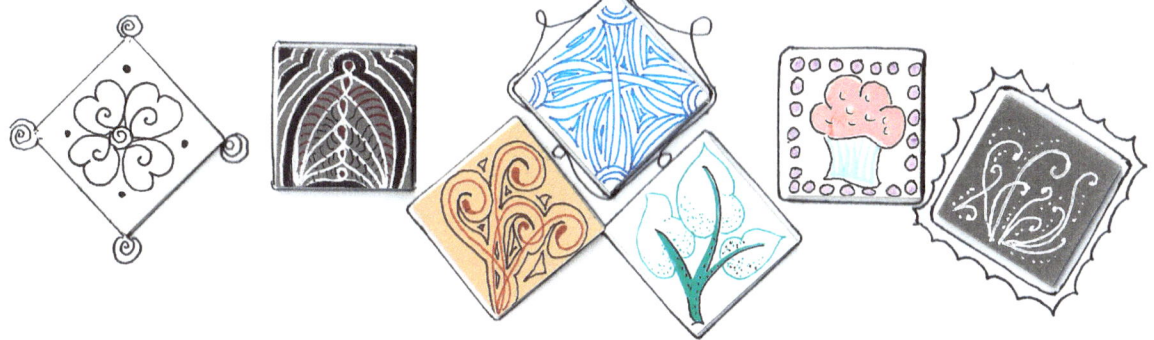

www.ingramcontent.com/pod-product-compliance
Lightning Source LLC
Chambersburg PA
CBHW050415180526
45159CB00005B/2285